HERMODDITIES
BY TEMPLE BATES

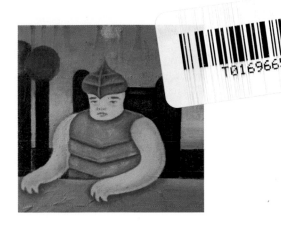

Extra production by Temple Bates and Tom Sardelic
Four panels in Pet Sponge by Drue Langlois (can you spot them?)
Title fonts scanned from *Scribner's Magazine*, March 1900

Library and Archives Canada Cataloguing in Publication

Bates, Temple, 1973-
 Hermoddities / Temple Bates.

ISBN 978-1-894994-57-6

 1. Bates, Temple, 1973-. I. Title.

ND249.B324A4 2011 759.11 C2011-903016-0

First Edition
Printed in Canada by Transcontinental

CONUNDRUM PRESS
Greenwich, NS
www.conundrumpress.com

conundrum press acknowledges the financial support of the Canada Council for the Arts and the
Government of Canada through the Canada Book Fund toward its publishing activities.

TABLE OF CONTENTS

PUBLISHER'S NOTE

I'm not sure when I first got my hands on a copy of *Catpeeps* but the point is I did. It had a visceral effect on me. It was a classic cut and paste zine (maybe I found it at a zine fair?) appropriating a catalogue, which is not unique, but the oddball concepts and drawings formed a distinct impression. My wife and I walked around the apartment for days, saying, "Sometimes Cats, Sometimes People," over and over again until it wasn't funny anymore.

Years later I found myself publishing a book of drawings by Shary Boyle called *Witness My Shame*. I'd never met her before but she slept in the spare bed in my office for three days and we put the book together. One day, during a break she announced she was going to meet Temple Bates for coffee, and that she had done a zine called *Catpeeps*. My wife and I both burst out simultaneously, "Sometimes Cats, Sometimes People!" I had to meet this Temple Bates. Was there more? The world needed to be exposed to more *Catpeeps*! That very day I contacted her and inquired as to their existence.

Alas! There was only one *Catpeeps* but she mailed me a handful of other amazing comics in the same vein, in which freedom only leads to confinement of a different sort. The idea of a pet being a prisoner in our world. Although I loved the comics of Temple Bates, at the time I needed to focus my energies on other projects. I never met the creator of *Catpeeps*.

Flash forward six years. I now have my own Catpeep named October who is polydactylic so he can open doors, and he talks, especially when I flop him over my shoulder and squeeze him like a bagpiper. Catpipes. He is a furry prisoner in my world. I reconnect with the creator of *Catpeeps*. This time there is a new

body of work, the creation of the Hermoddites has been in full swing, they are populating the world as we speak. Like spores. Bates' paintings are as odd as her Catpeeps but there is so much more here. Each one is a character, a woolly-cheeked critter with a backstory, living in forests, but sitting uncomfortably long enough to be painted. There is a sense of timelessness here; are these creatures medieval or futuristic, children or old men? Hermetic oddities, hermaphrodites. Sometimes cute, sometimes cruel.

Who are the Hermoddities? Why not pay them a visit? They look and look. Why not challenge them, confuse them? In a fevered dream I visit the Bates Hotel. There is no doorbell so I am stymied. I sit and wait on the covered porch. Eventually a tenant pokes his head out the door. He has woolly cheeks but more in a lazy student way than a Hermoddity. I notice his collar is distinctly not frilly. "What are you doing here?" When I explain that I am waiting for the creator of *Catpeeps* he says, "Sometimes Cats, Sometimes People," and we share a cigarette even though I don't smoke. Its effect magnifies my fevered state. "How do you receive visitors without a doorbell?" I ask. "Cellphones." I feel like a country mouse among the city folk.

Eventually he trusts me enough to show me into Bates' apartment, seemingly without a key. It's a shotgun apartment but only a single barrel. "I'm sure she'll be home soon," he says scratching an itch. "Make yourself at home." I feel uncomfortable but also curious. Like her cat which eyes me. There is a group of boys playing basketball against the exterior wall of the building, where the hoop is affixed. I can hear the *thump thump* when they miss a shot. The studio is down the hall in the back. There is a small bed for a dwarf or a cat. Fluffballs gather on the sheets, ready to be caught for hats. This studio is a tiny room, no bigger than a bathroom really, but it is populated with creatures, varmints, and other oddities. Like being in a brain. This is the hive, the space where the Hermoddities are born.

There are many paintings on the walls, and many more turned around, like they've been tucked into bed. I recognize the artist in a painting of her clones holding a cloud, Temple as pillars of the cloud temple. I look deep into her oils and notice a world behind them, a one of a kind hideaway. Ribbons and whiskers, crystal, a bleeding pin cushion, and a carousel. *Thump thump.* A lifeboat holds a whole hamlet of Hermoddities. One of them casually drowns. Here they are in progress, the Hermoddities *in utero.* The sinister and the kind. Always looking, looking. The *thump thump* like a tell-tale heart. It is too much for me to be in here without a guide. I am like a pet. Luckily I am polydactylic and can open doors. I do so and run from the Bates Hotel. I look for a payphone but they have all disappeared.

Eventually I do meet Temple Bates. I recognize her from her paintings, but she is taller. We go to a coffee shop that shall remain nameless. We hash out the plan to make the book you now hold in your hands. Sometimes comics, sometimes paintings. Let's take a look shall we. There will be no unpleasantness about it at all.

— Andy Brown, May 2011

COMICS

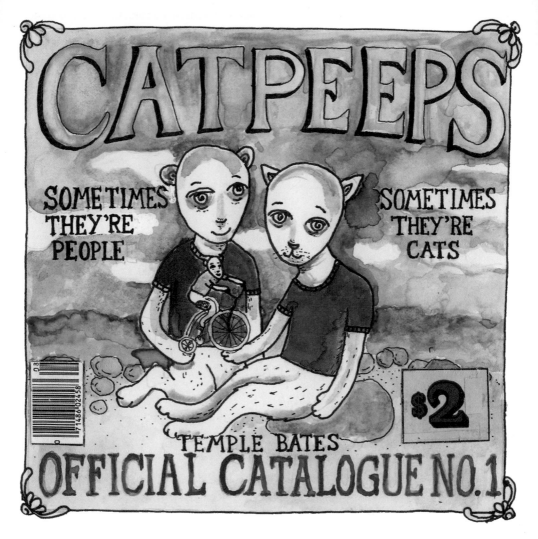

CATPEEPS CO. LTD.

12

CATPEEPS CO. LTD.

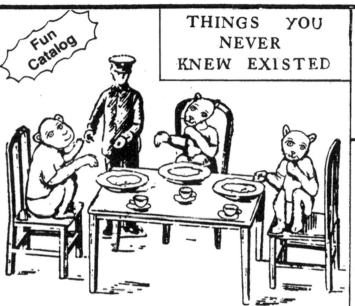

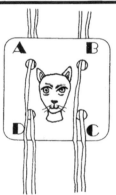
13

CATPEEPS CO. LTD.

☐ 2004. CATPEEPS cola

Keep cool
wherever
you go.

ONLY 25¢

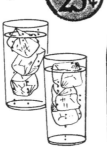
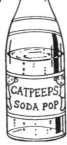

7/R4241.	Height, 5 ins.	15 -	doz.
7/R4242.	" 6½ "	22/6	"

☐ 2724. CATPEEP PIGGY BANK

Looks mean.

Each
brightly colored

In attractive gift box.

Price **$1.95**

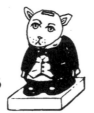

7/M3047.
CATPEEPS
ROCKET BALLOON

Looks harmless enough.
until they light it up.
What happens next is
unbelievable! erupts
like a volcano.
Also makes excellent
psychedelic party light.
Really get into the music
& the mood with
brilliant red beams
revolving eerily
around the room.
Fantastic fun bargain
Complete with ammo
for about 20 "blasts."

Guaranteed big
& especially scary

Do over & over.
In attractive gift box.

2059 $2.95
2060 Refill 99¢

CATPEEPS CO. LTD.

☐ 7001 CATPEEP PUPPET IN A CONE

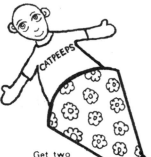

Get two
one for each arm.

Offer to friends or leave
on table or counter stand
back & watch the fun.

lightweight & convenient

PUPPET............ $3.95

☐ 2735. mesmerizing experiment

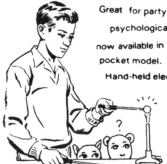

Great for party fun. scientific.
psychological experiments.

now available in low-priced transistorized
pocket model. Easy to use.
Hand-held electrodes. Easy-read dial.

Complete instructions.

They look & look.

Challenge them
Confuse them.

PRICE......................... $3.75

5496. Bath toy

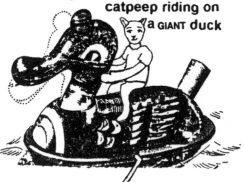

catpeep riding on
a GIANT duck

Packed in box complete with specially
designed flippers

made in the following sizes—

7/R4243.	,,	8 "	35/- "
7/R4244.	,,	9½ "	46/6 "
7/R4245.	,,	11½ "	63/- "
7/R4246.	,,	14½ "	87/- "
7/R4247.	,,	16 "	120/- "

Price.................... $2.15

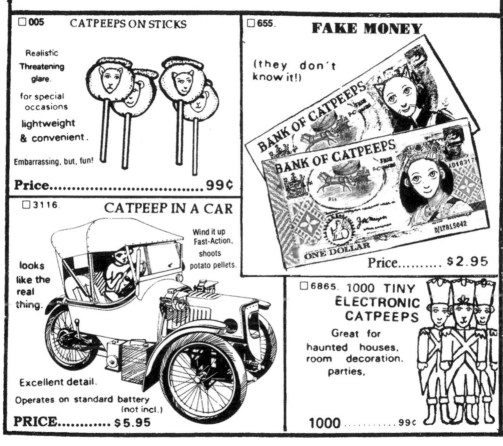
16

CATPEEPS CO. LTD.

☐ 3072. CATPEEPS Decal

Nothing is lit or burned.
Sticks to any surface

PRICE.. $1.95

☐ 9395. **CATPEEP MASK**

For stage use. comic
dis guises.
you'll soon forget
you're wearing it!

adjustable.

Remove
with
soap,
fast.

Make Up. 99¢

☐ 9527 **PINBALL MACHINE**

Easy on-off 7 piece kit.

feel those frustrations

drain away. Amazing speed.
On-off switch. 7½" long.

Only
$2.95

Brilliant colors.
With light diffracting
prismatic background.

Simply press switch and
this beauty rises and floats in
any direction you wish.

Price.. $2.95

5496 Pocket watch

Handy poc-
ket size
Calibrated dial.
...... $1.49
yellow. $1.49
Red $1.00
Black $1.49

☐ 3885 **DOME**

authentic
With suction cup
base.

About 4"x3"

Price................. $1.49

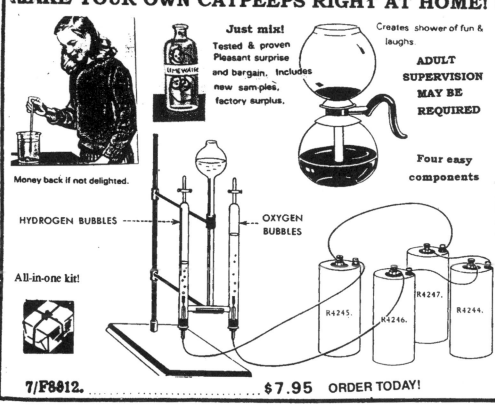
18

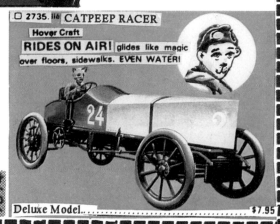
19

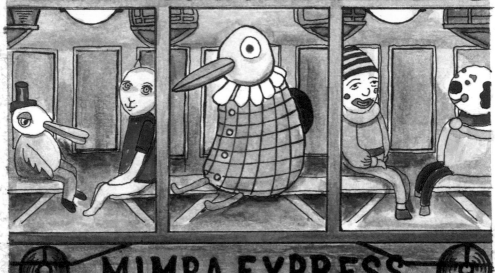

PUBLISHED · BY

Bird with a
Ball Foot BOOKS

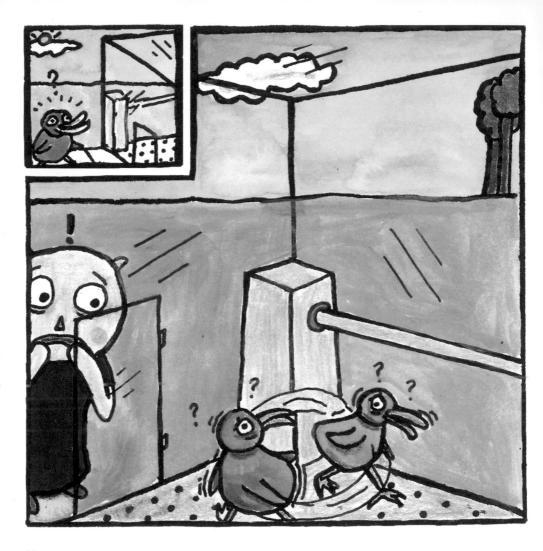

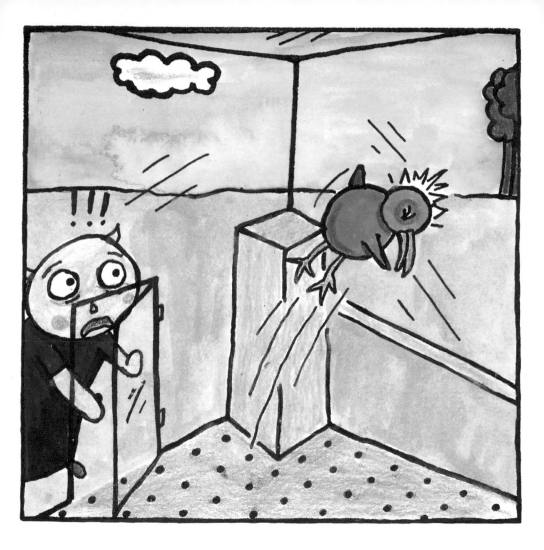

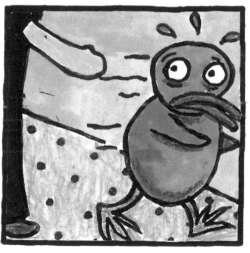
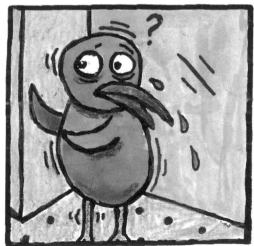

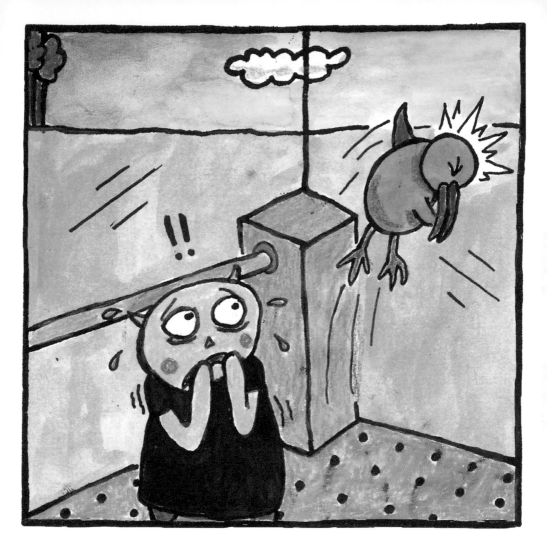

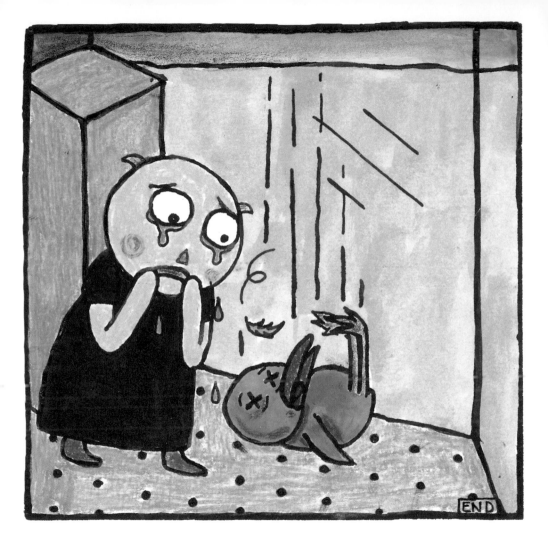

Run BIRD Run

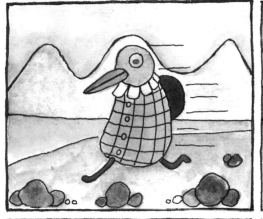
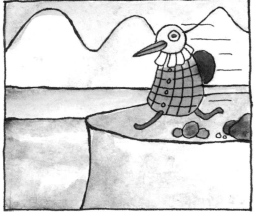
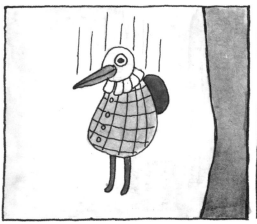
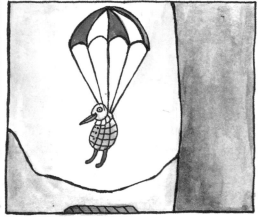

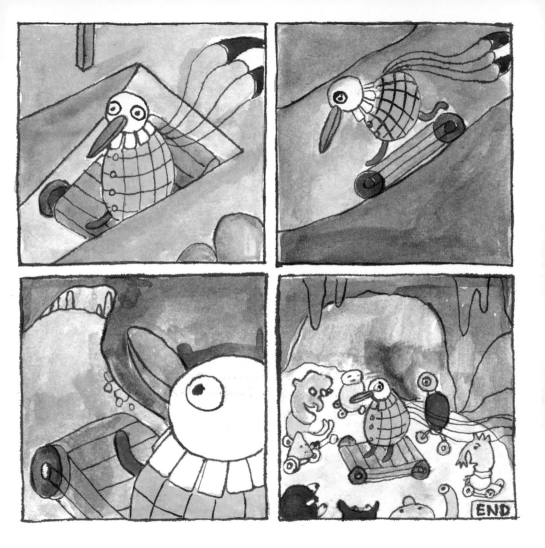

END

31

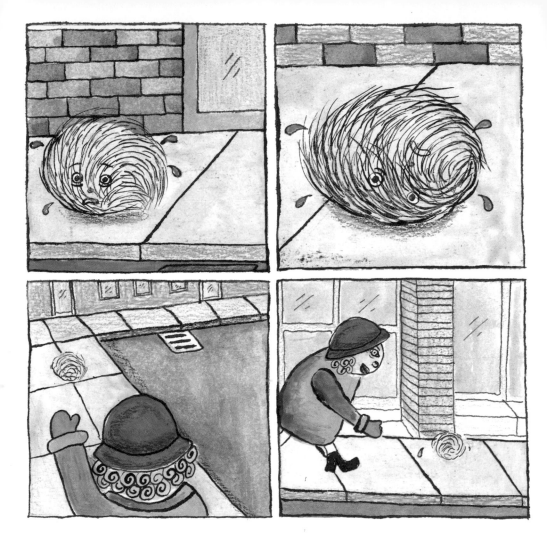

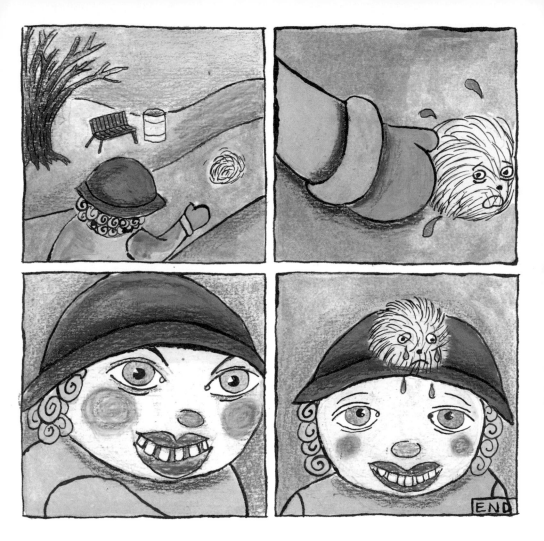

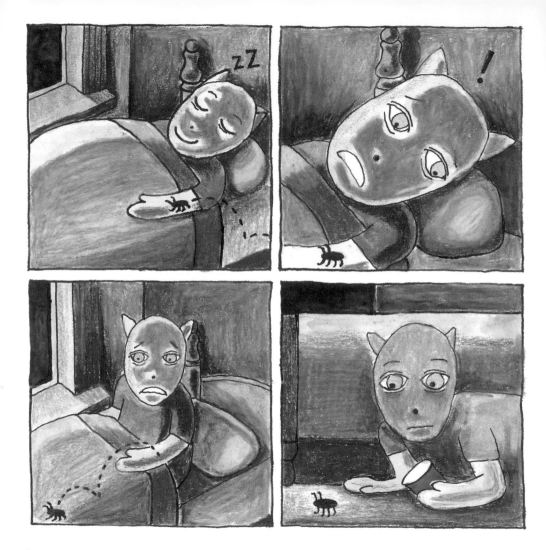

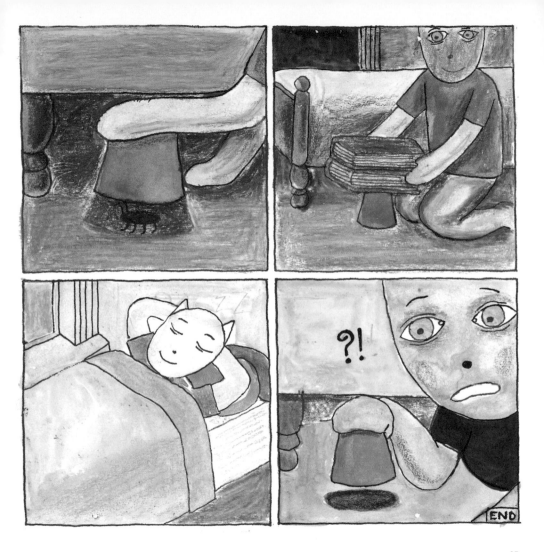

GRABBIN' TIME AGAIN!

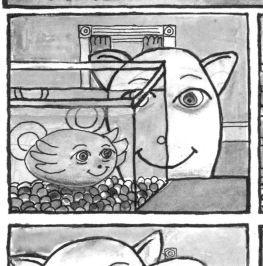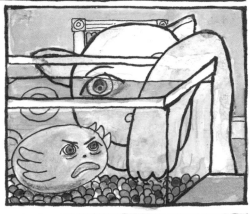

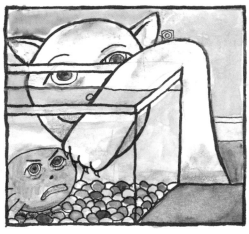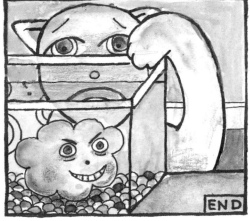

END

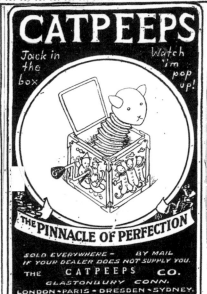
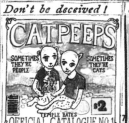

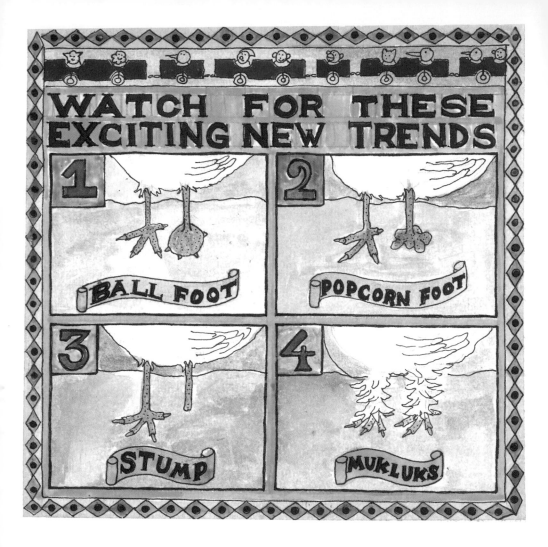

38

BAD BIRD!

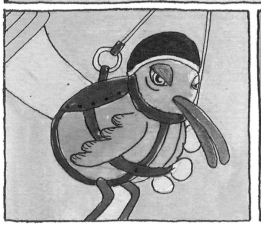

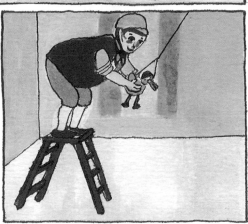

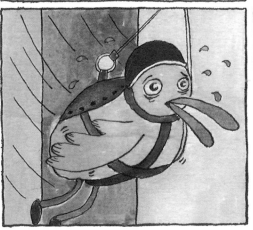

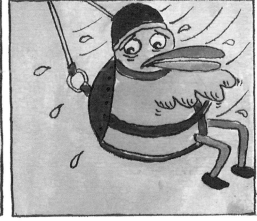

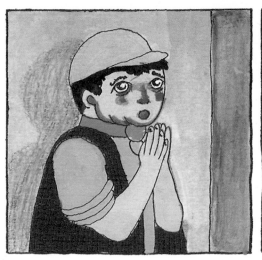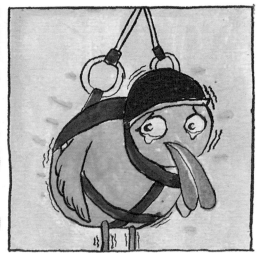

END

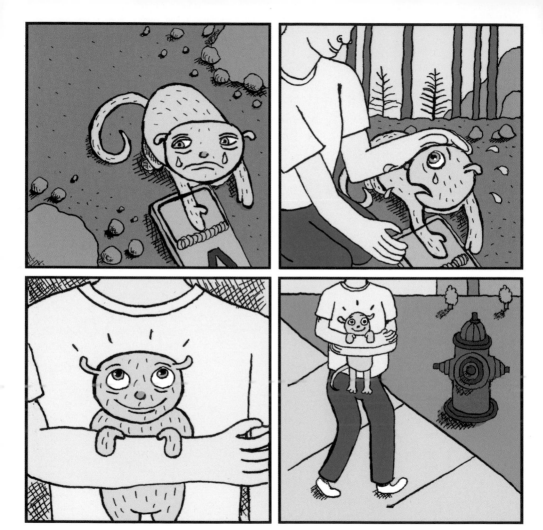

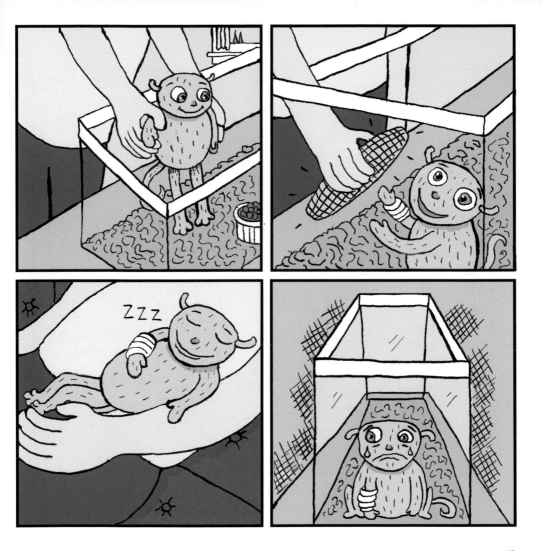

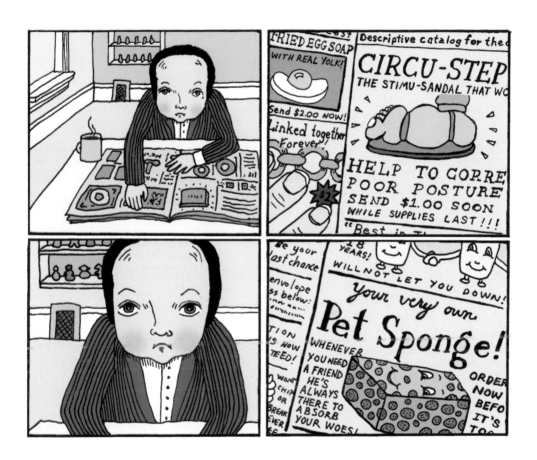

MEANWHILE, AT THE FACTORY...

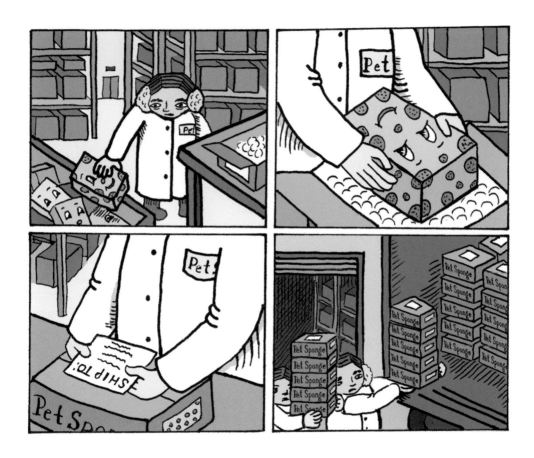

47

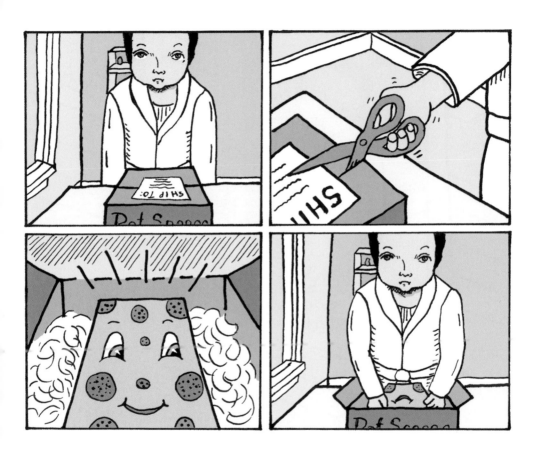

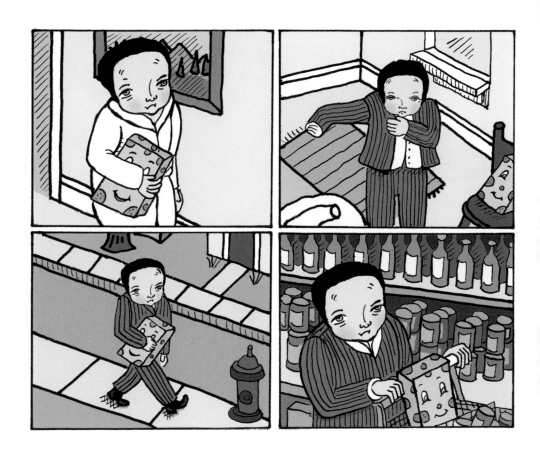

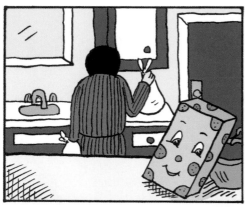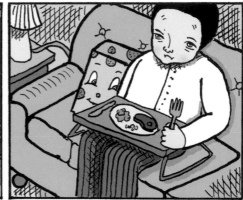

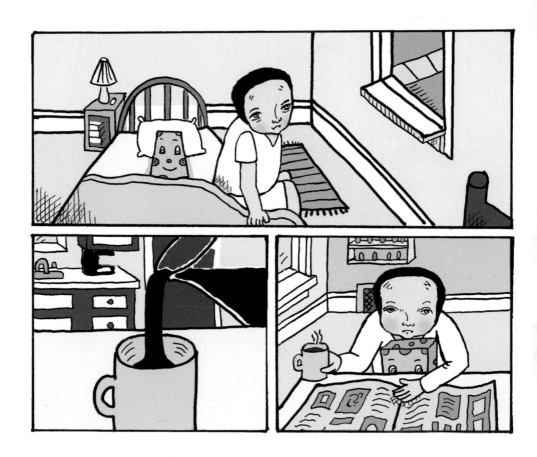

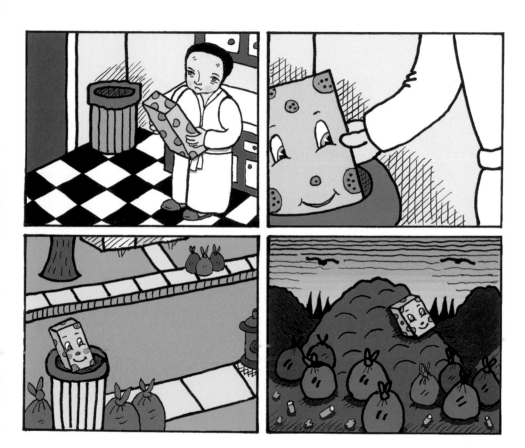

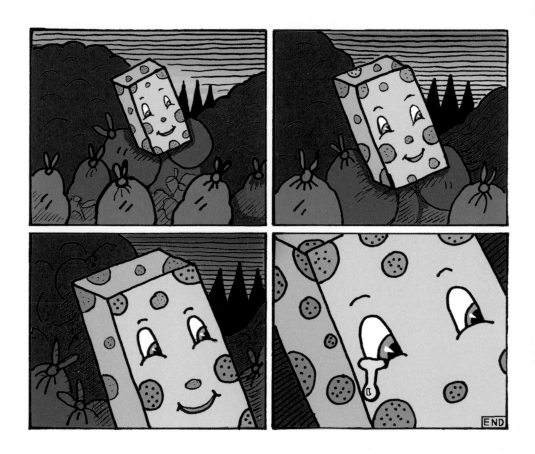

END

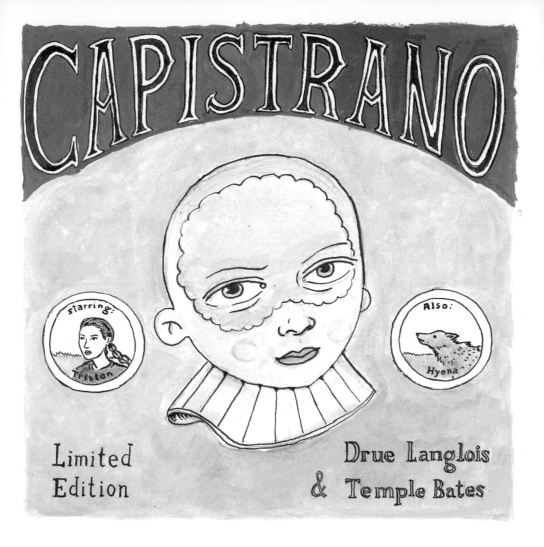

CAPISTRANO

starring: Tristan

Also: Hyena

Limited Edition

Drue Langlois & Temple Bates

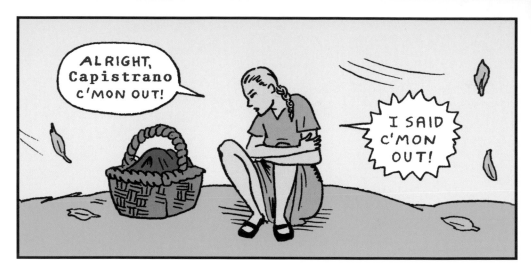

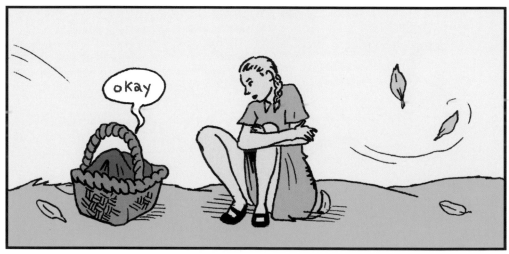

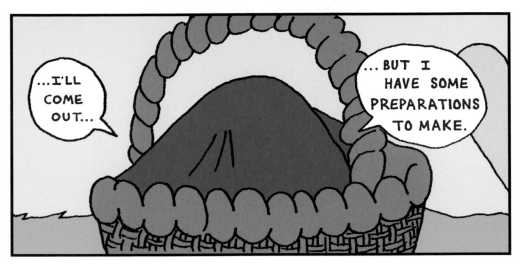

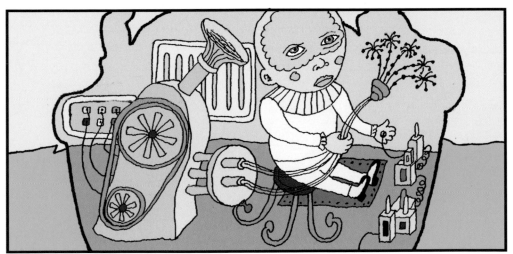

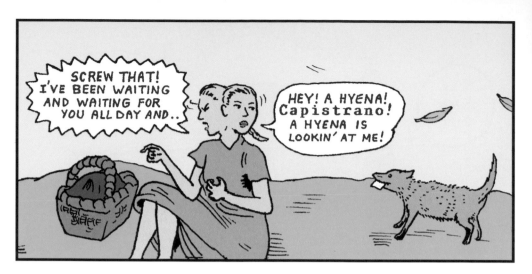

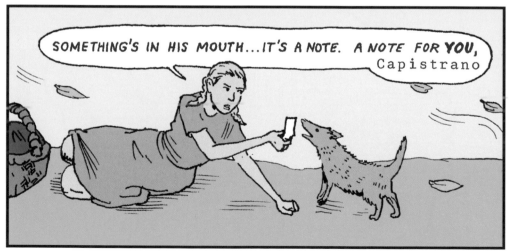

60

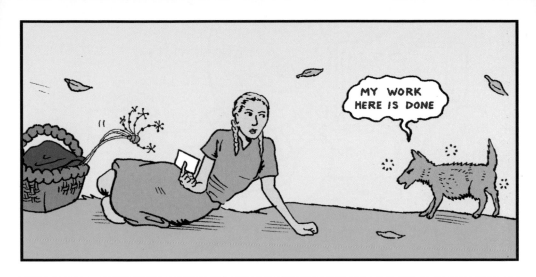

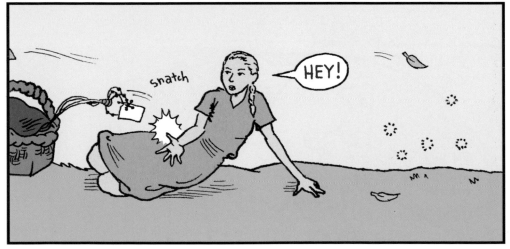

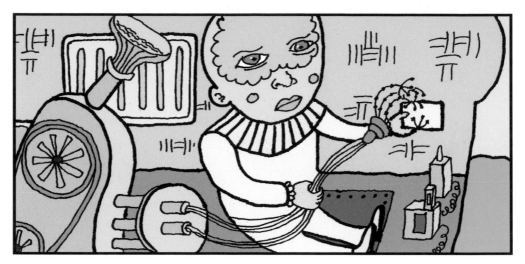

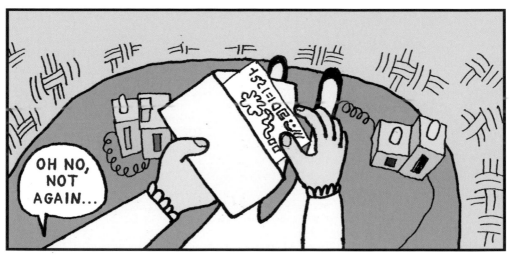

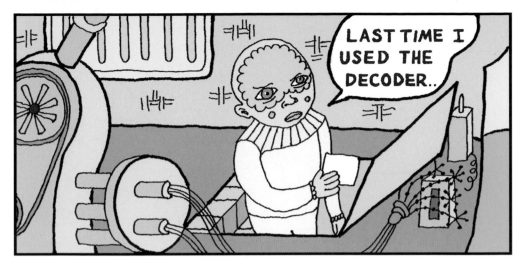

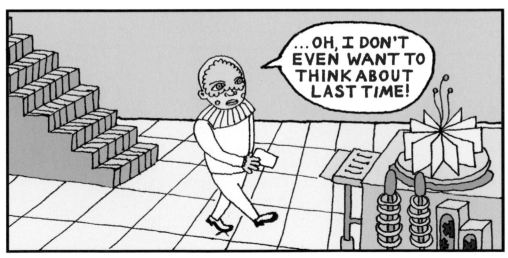

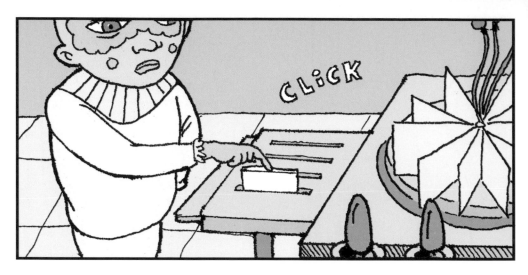

CLICK

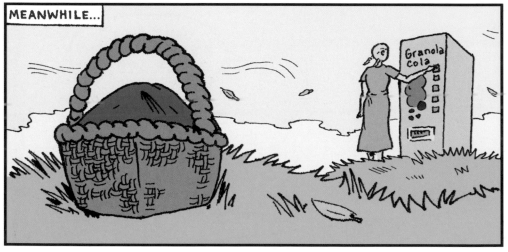

MEANWHILE...

Granola Cola

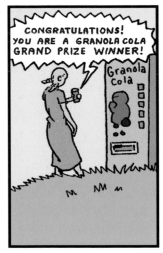

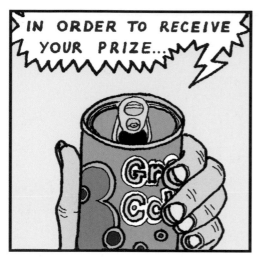

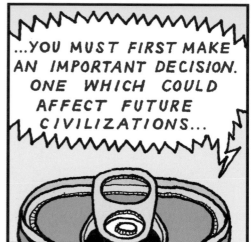

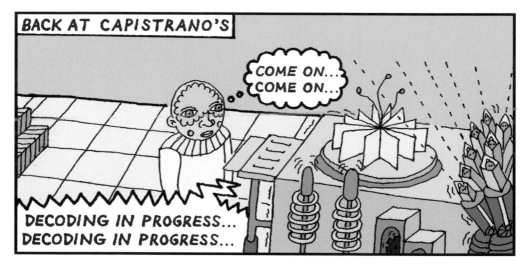

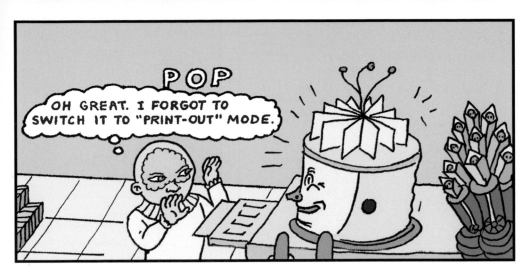

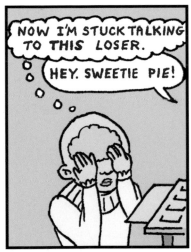

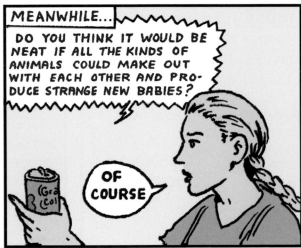

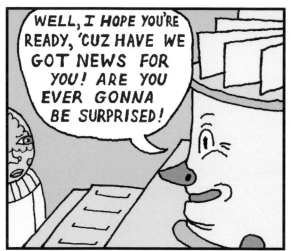

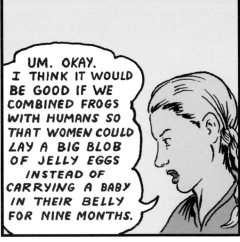

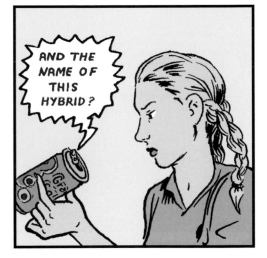

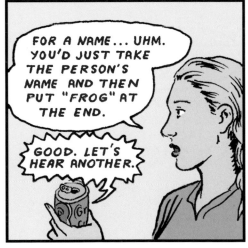

69

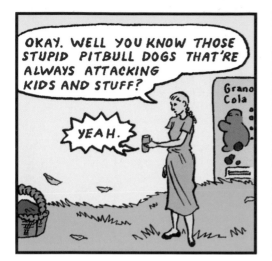

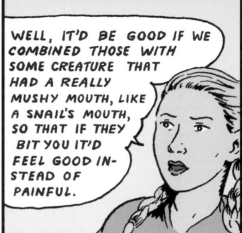

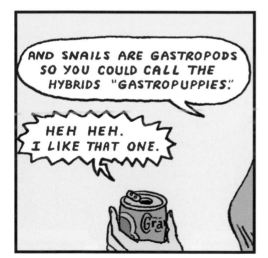

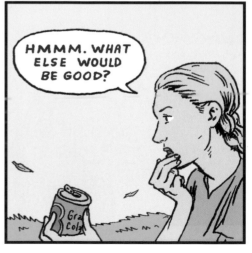

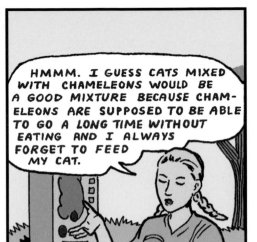

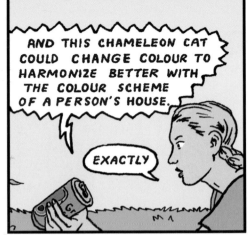

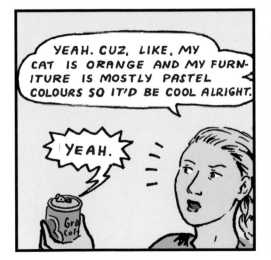

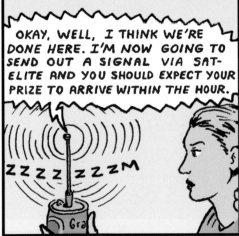

71

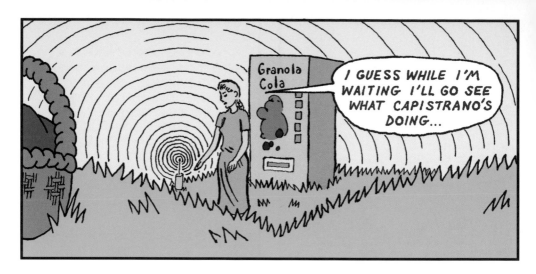

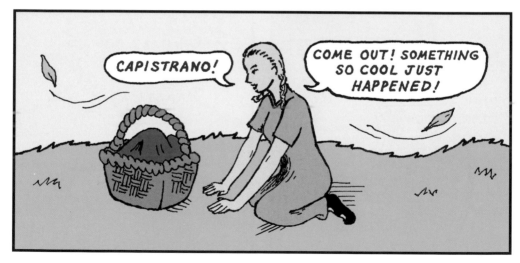

74

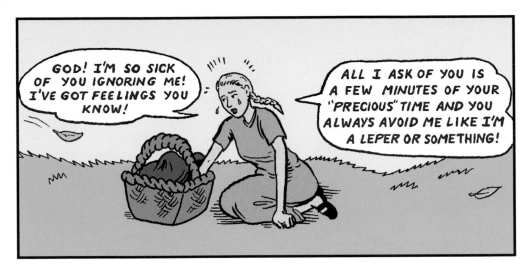

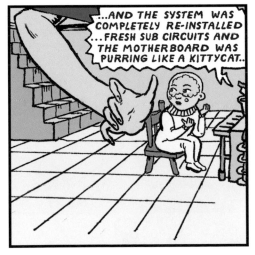

75

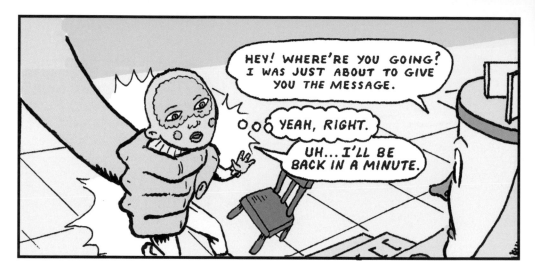

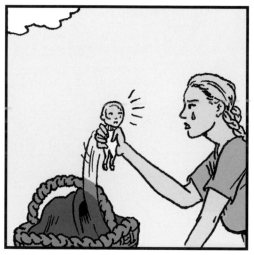

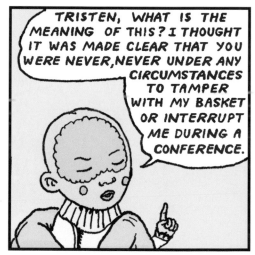

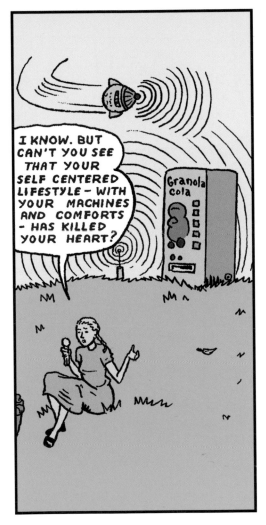

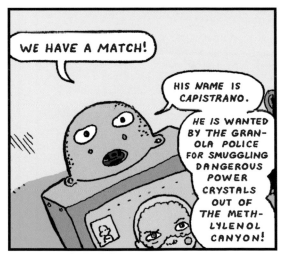

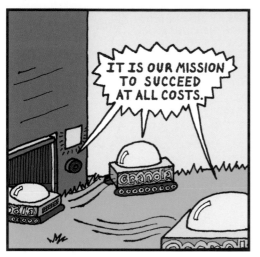

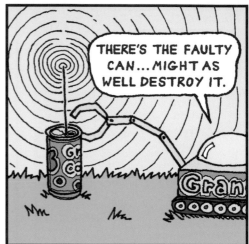

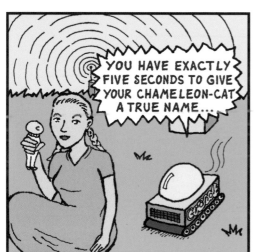

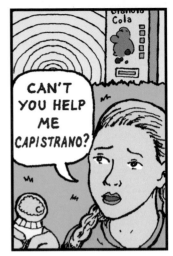

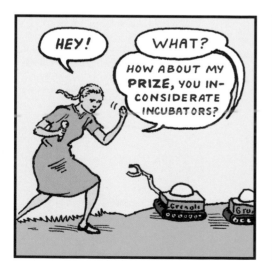

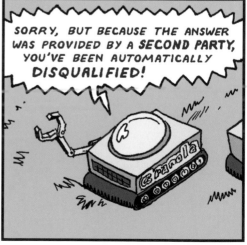

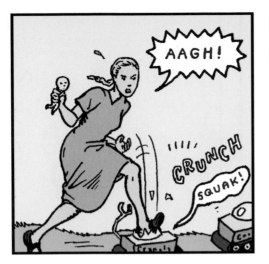
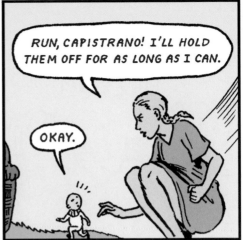

84

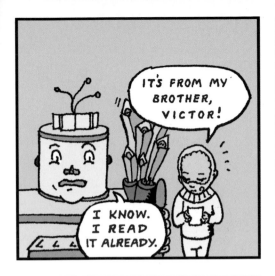

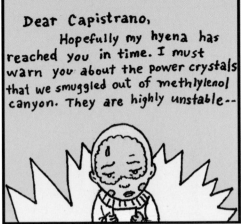

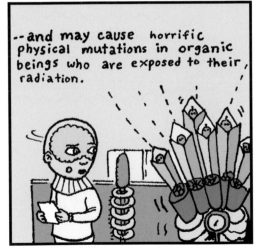

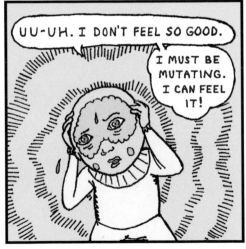

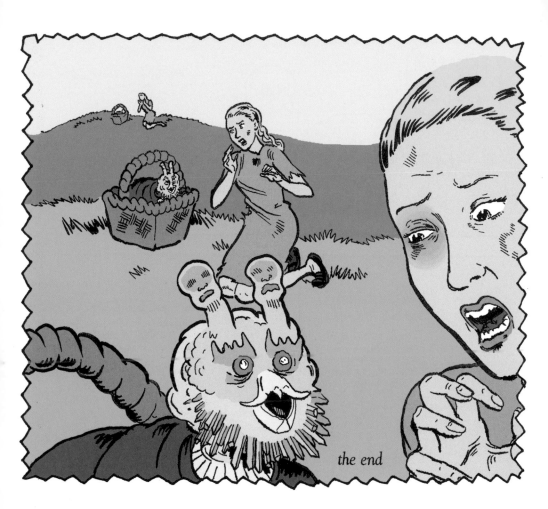

the end

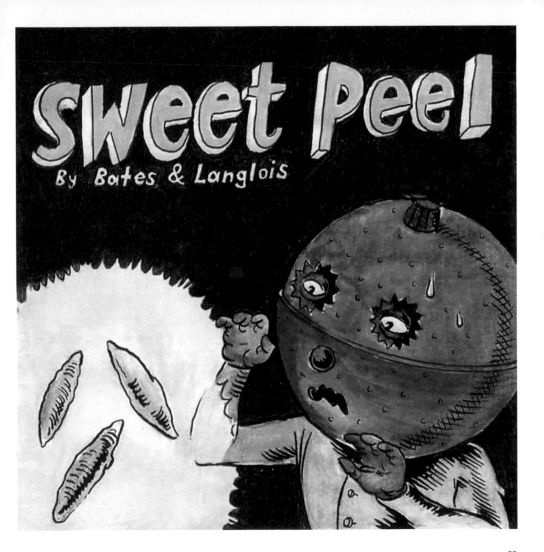

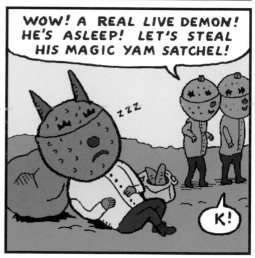

94

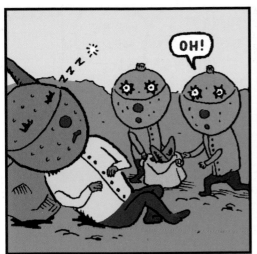

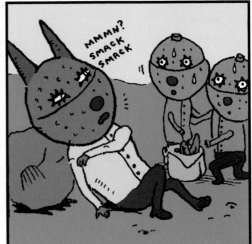

97

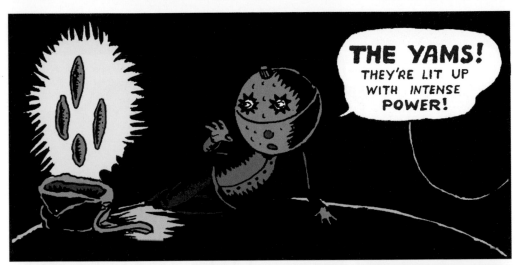

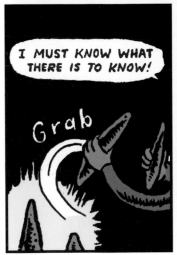

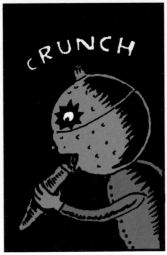

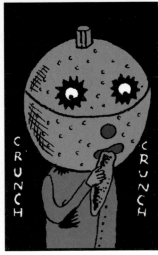

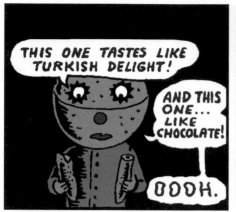

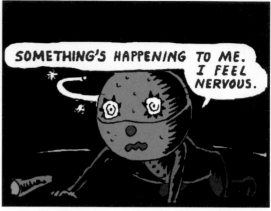

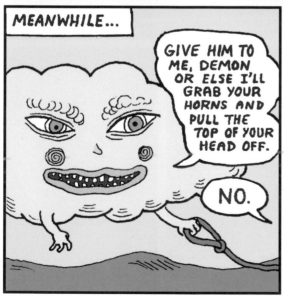

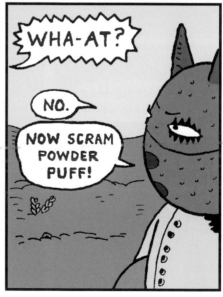

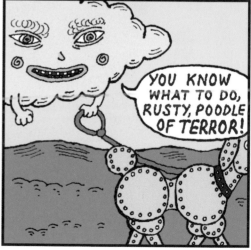

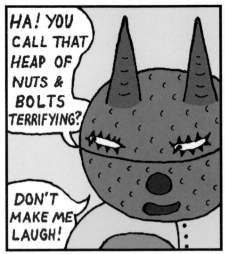
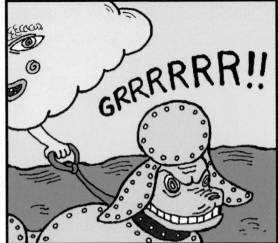
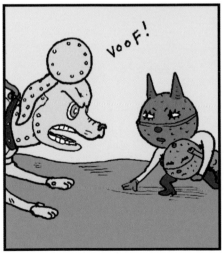

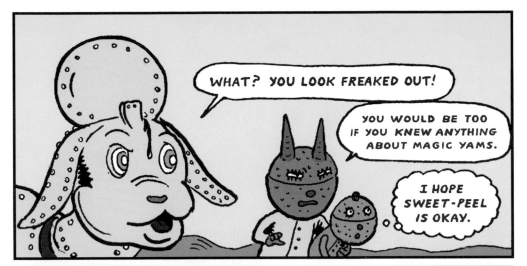

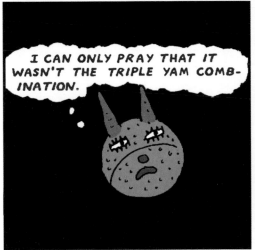

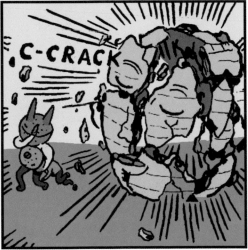

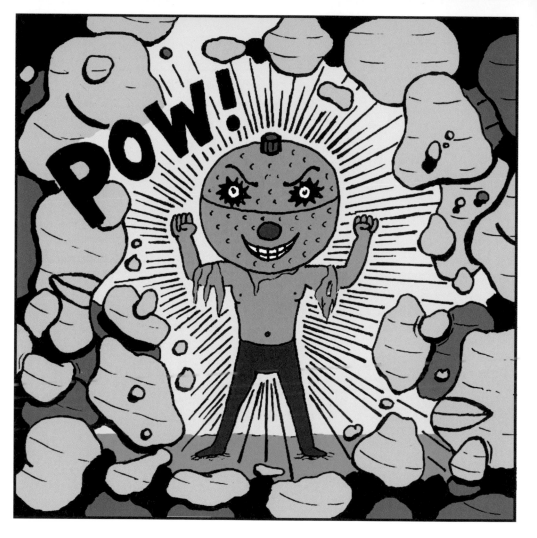

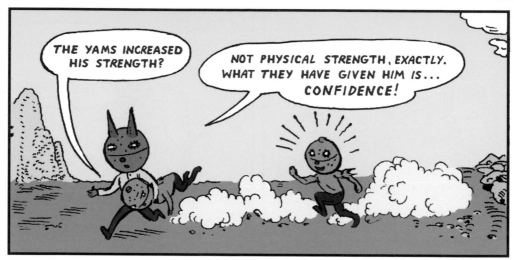

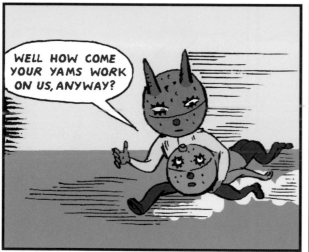

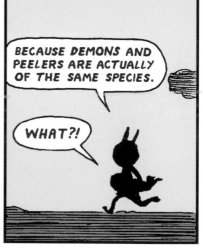

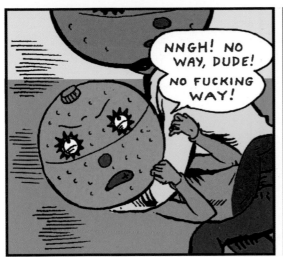

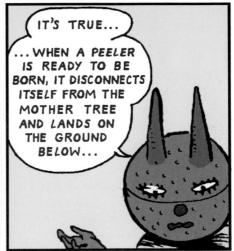

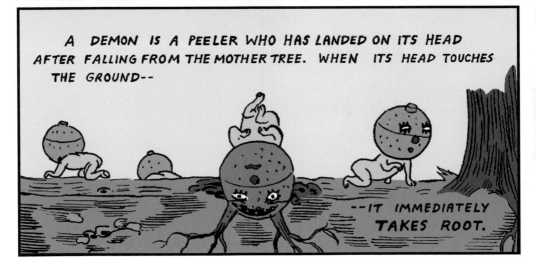

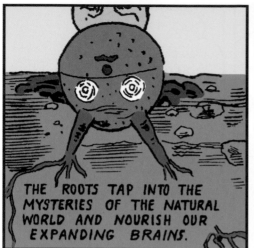

THE ROOTS TAP INTO THE MYSTERIES OF THE NATURAL WORLD AND NOURISH OUR EXPANDING BRAINS.

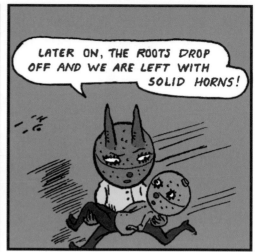

LATER ON, THE ROOTS DROP OFF AND WE ARE LEFT WITH SOLID HORNS!

I... NEVER...

..I NEVER KNEW THAT.

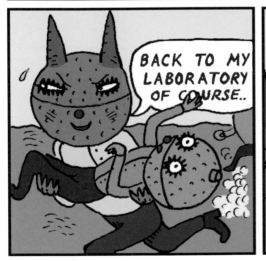

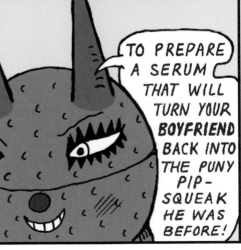

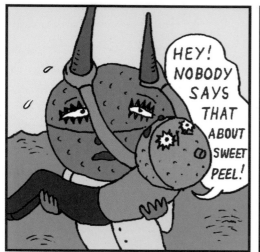

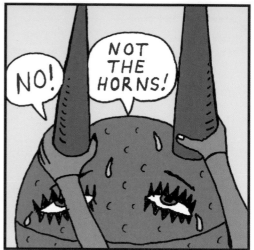

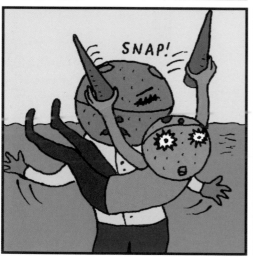

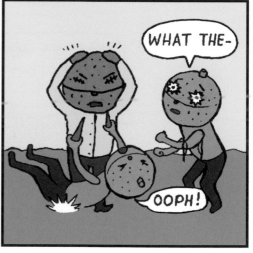

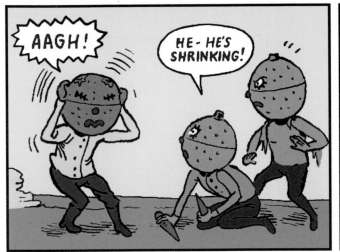
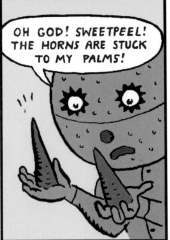

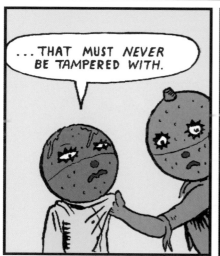

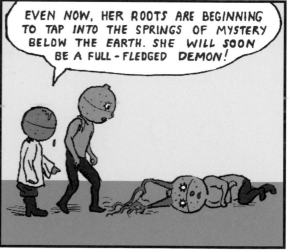

114

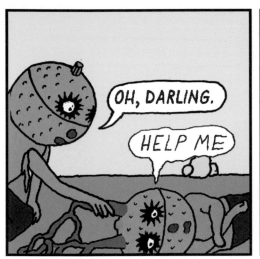

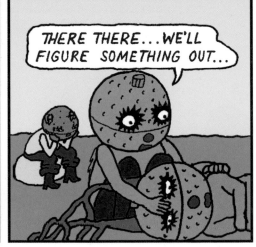

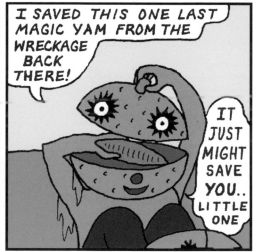

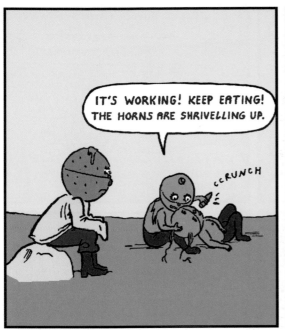

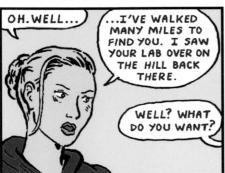

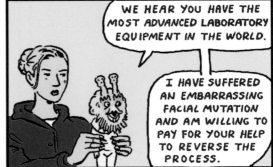

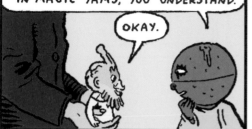

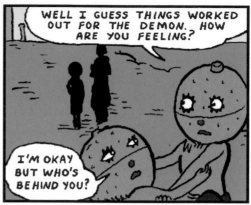

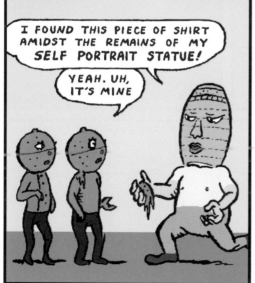

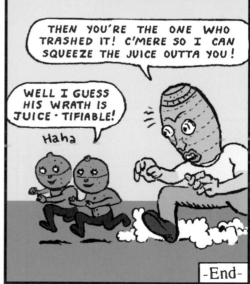

-End-

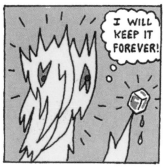

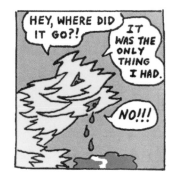

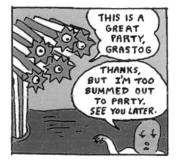

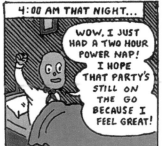

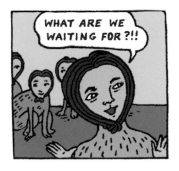

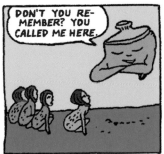

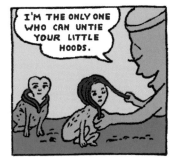

PAINTINGS

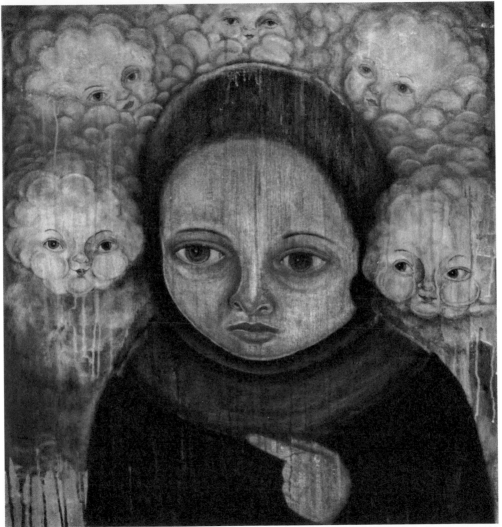

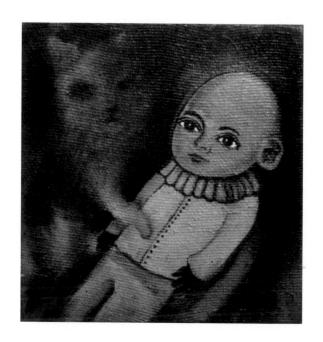

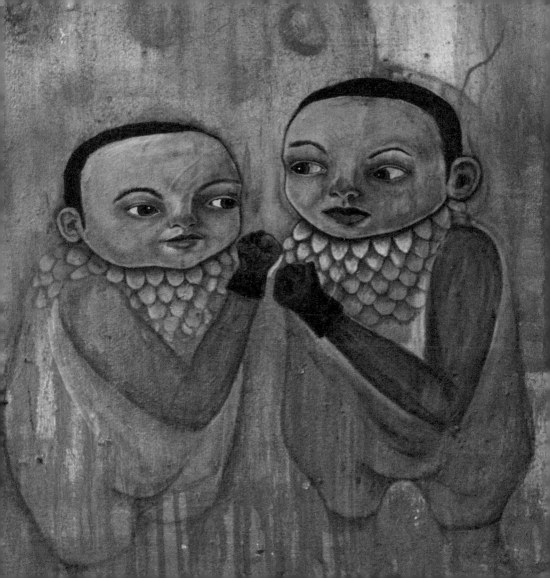

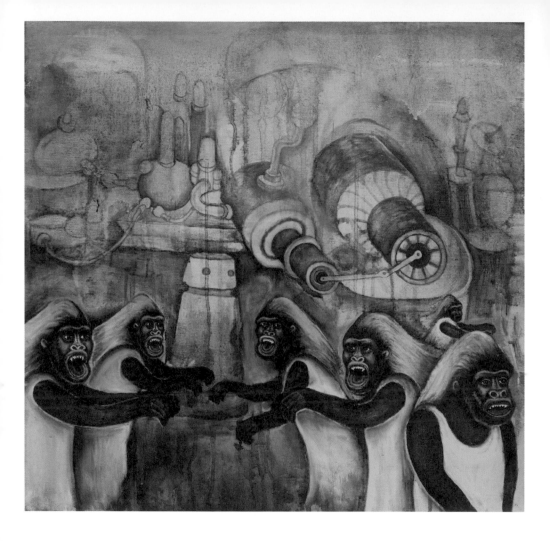

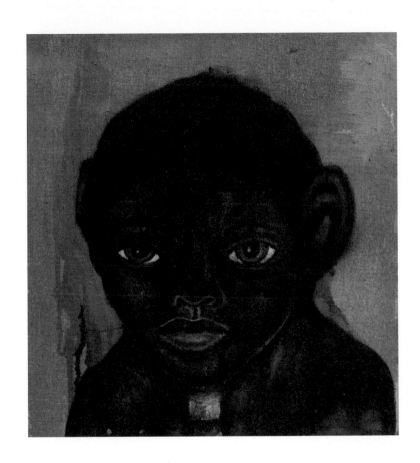

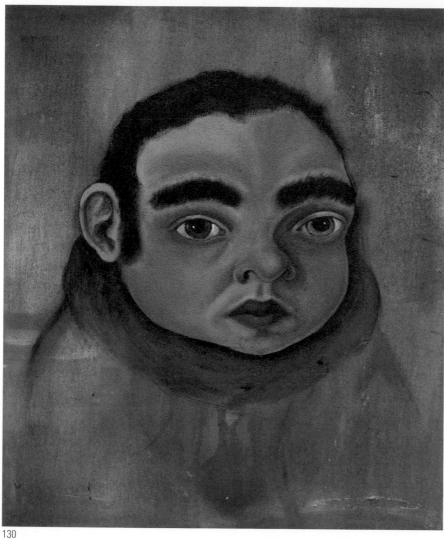

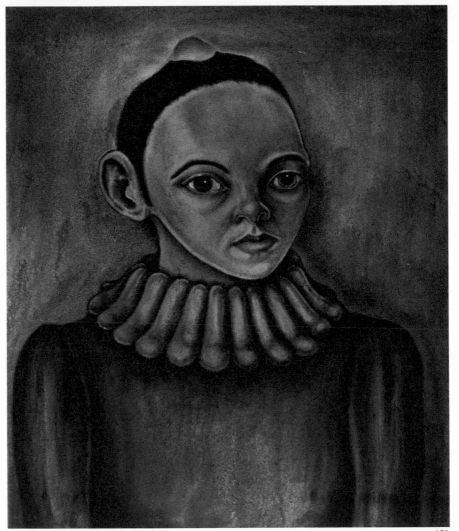

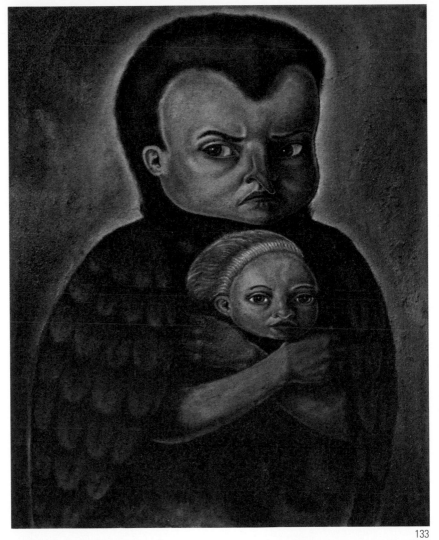

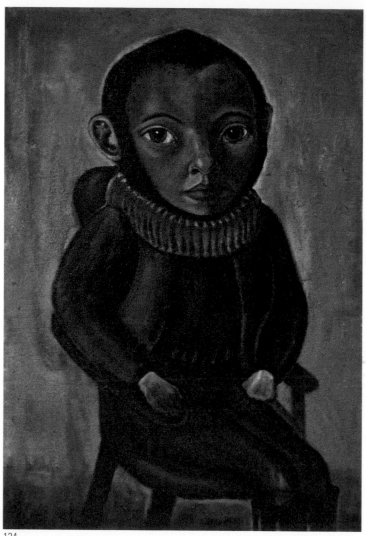

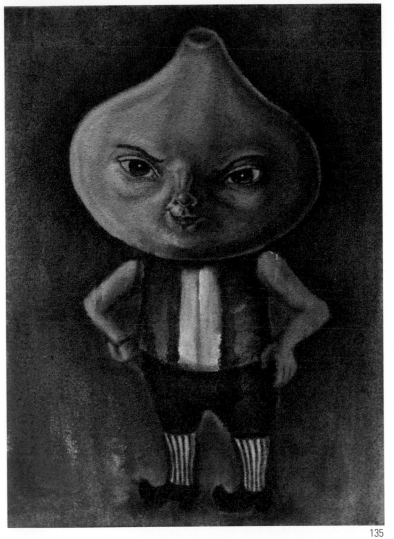

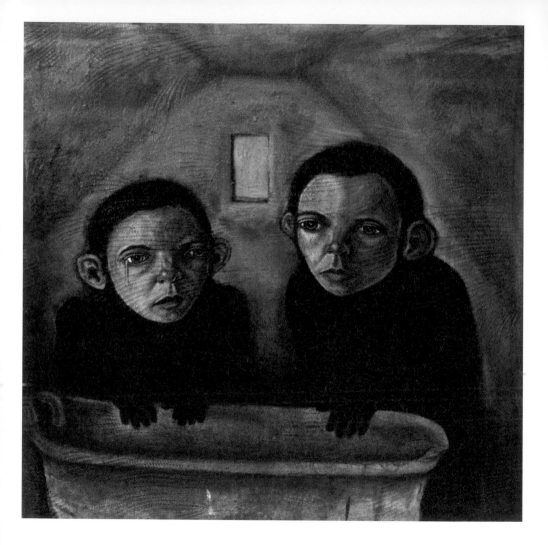

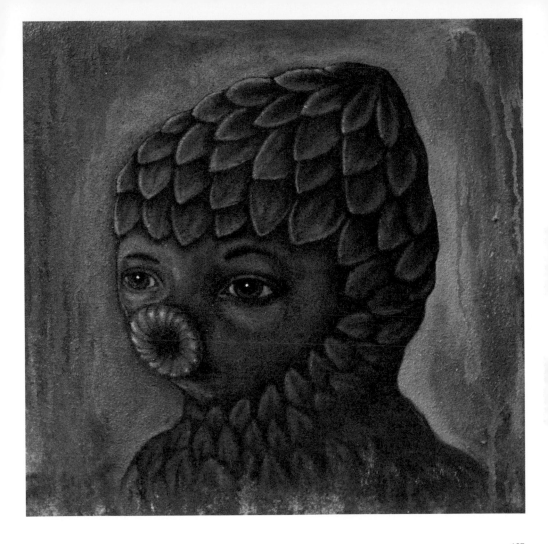

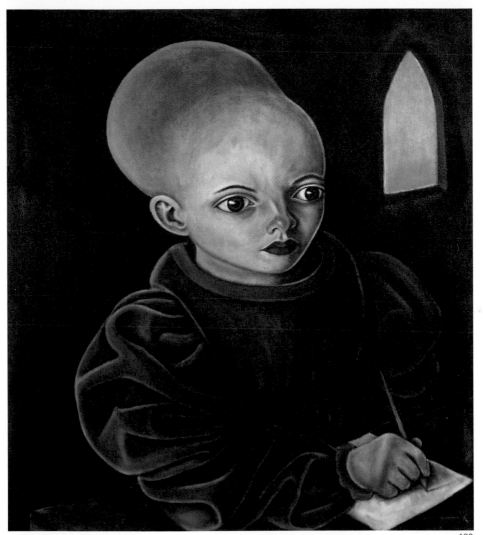

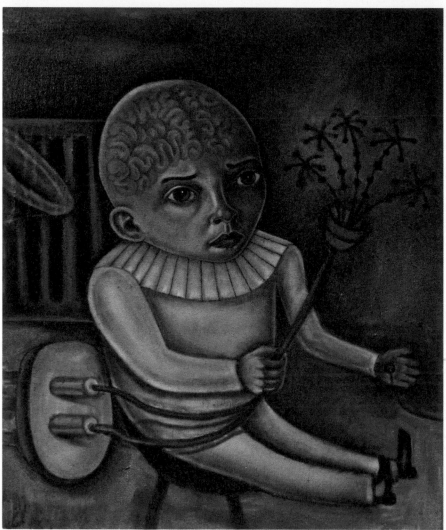

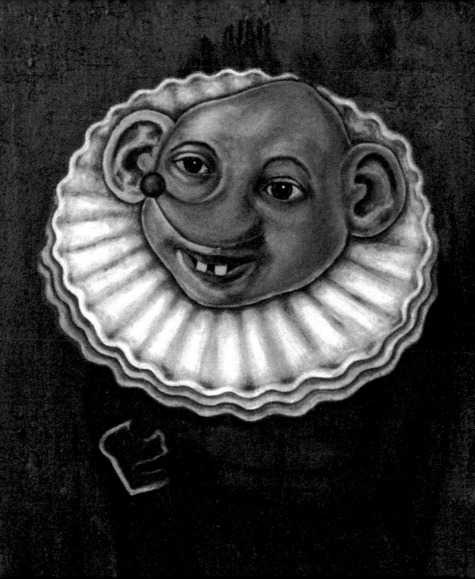

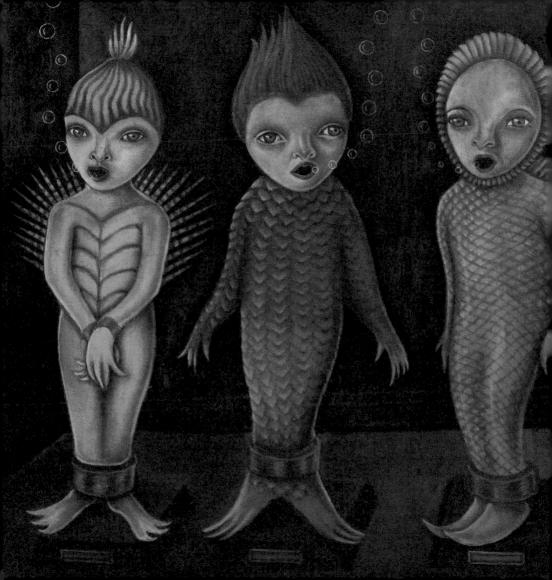

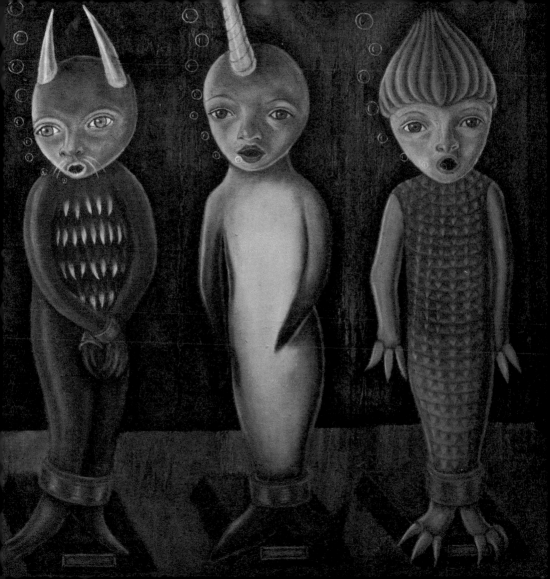

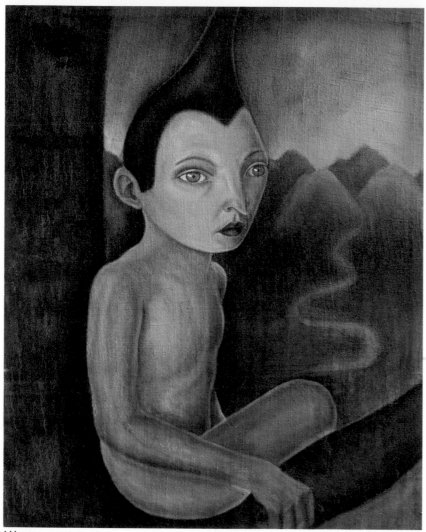

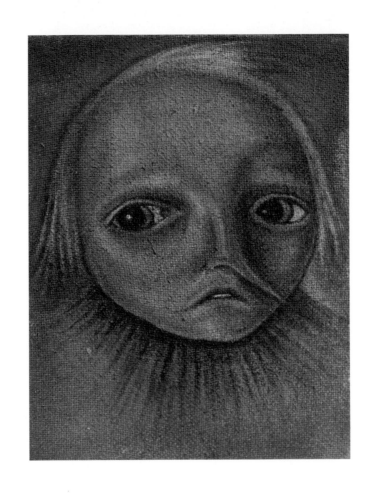

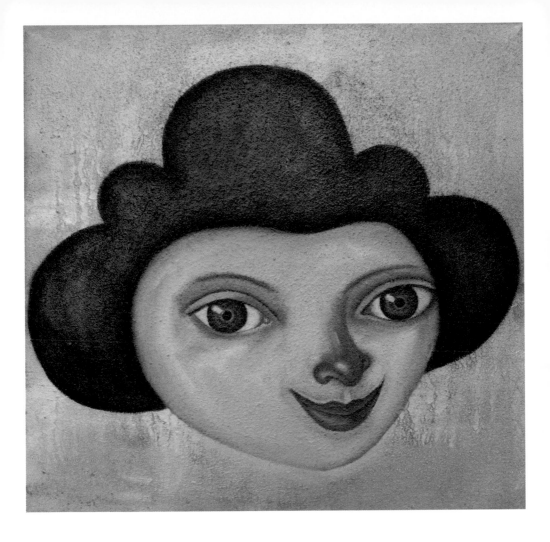

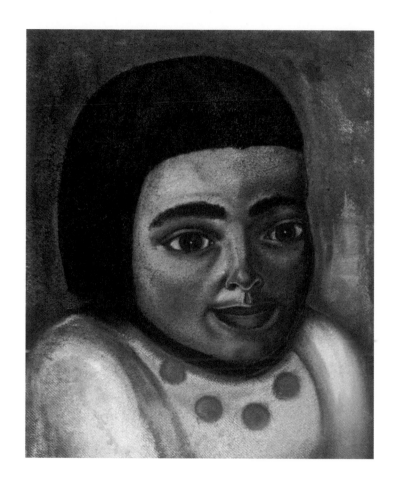

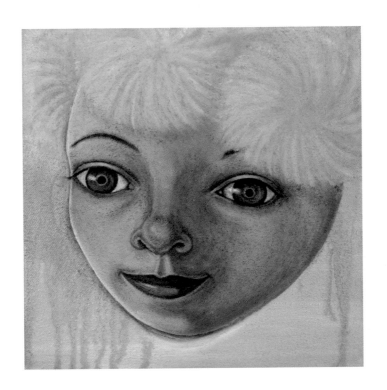

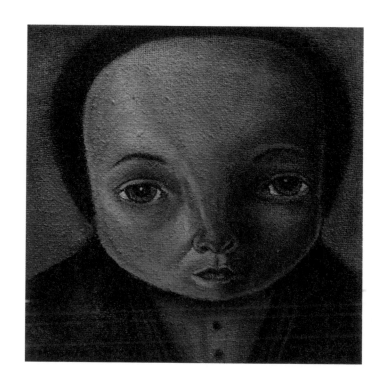

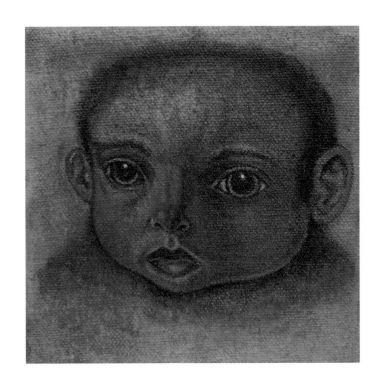

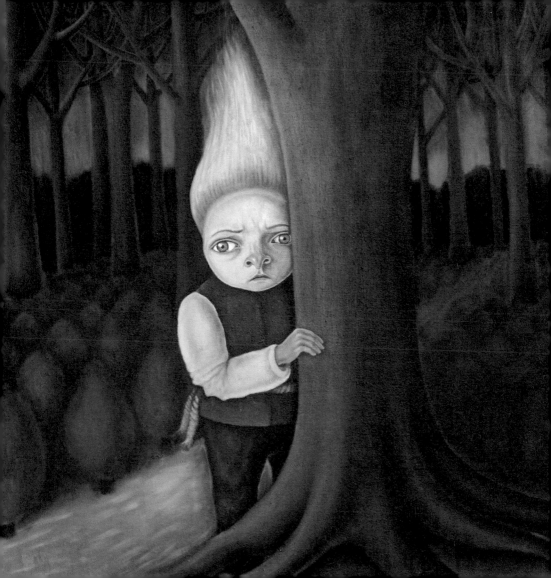

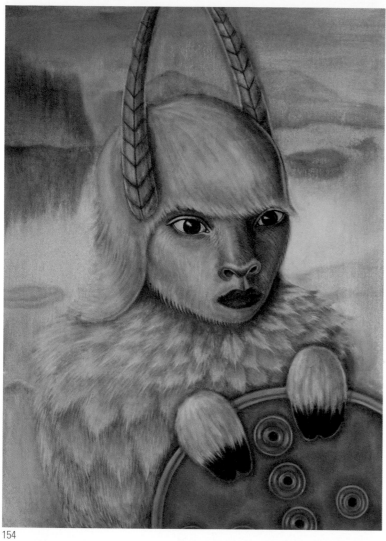

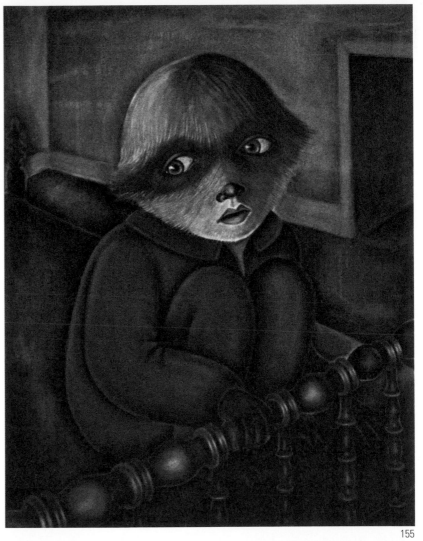

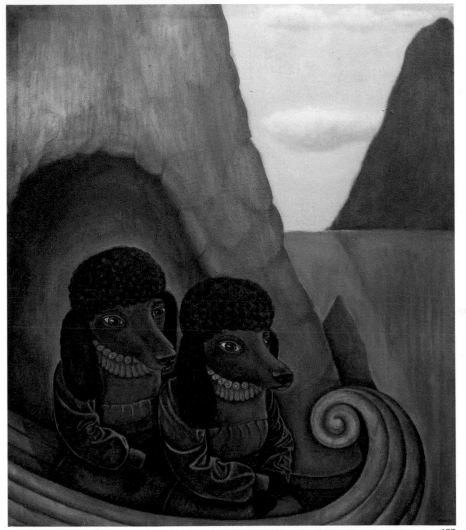

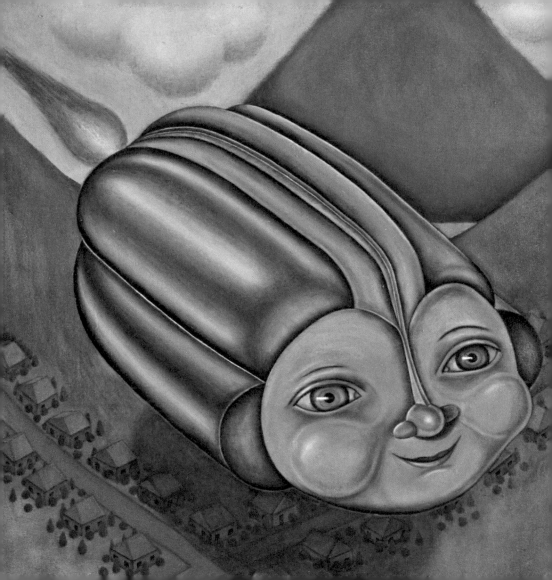

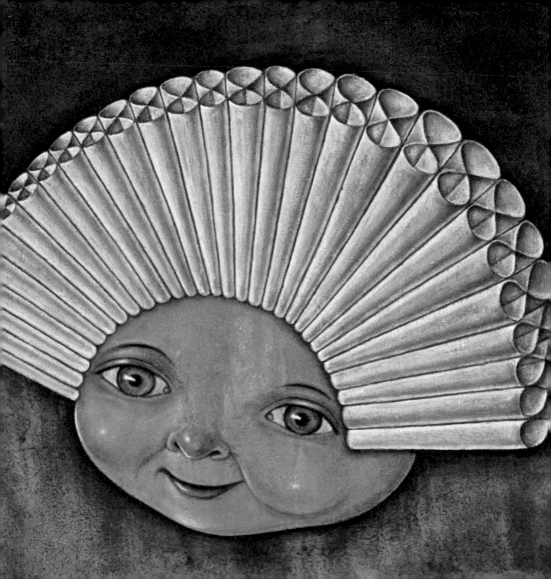

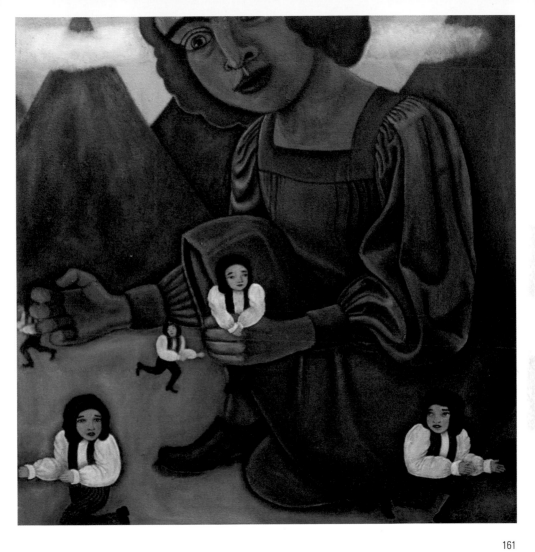

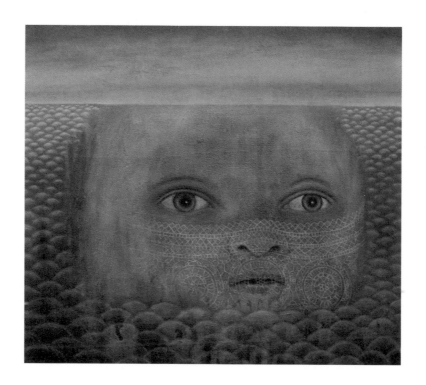

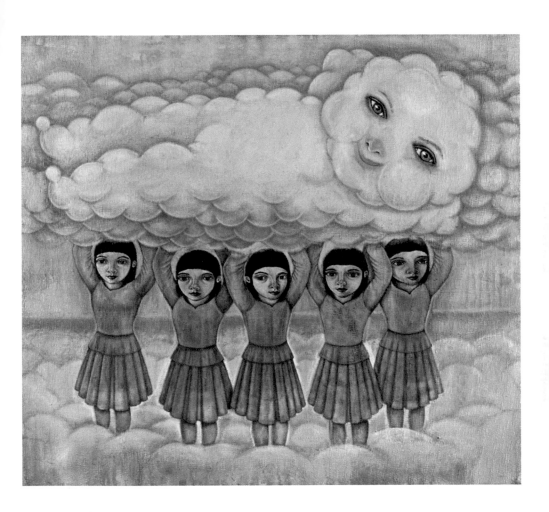

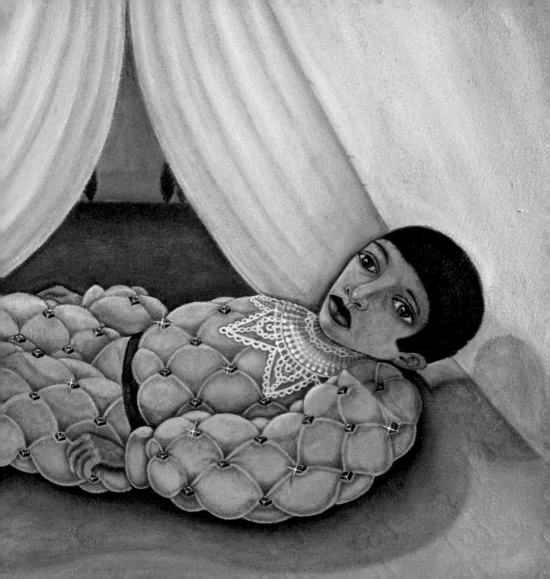

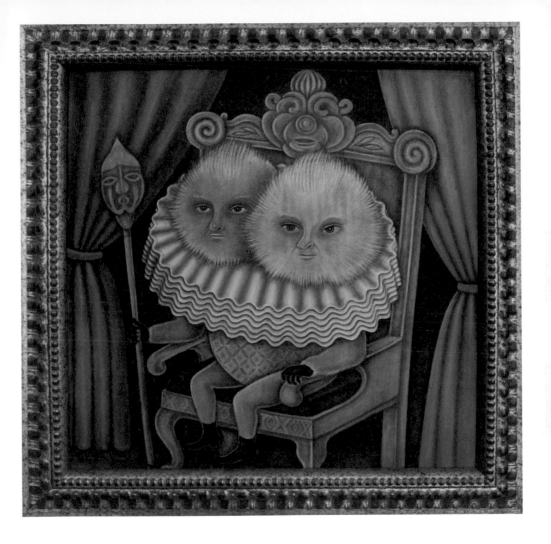

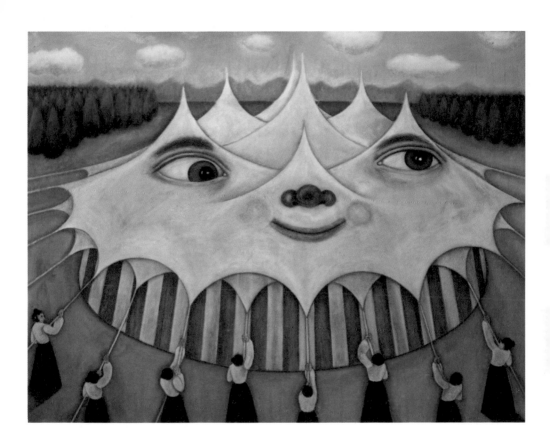

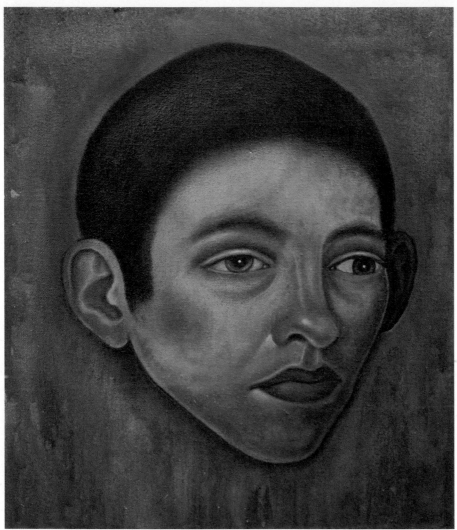

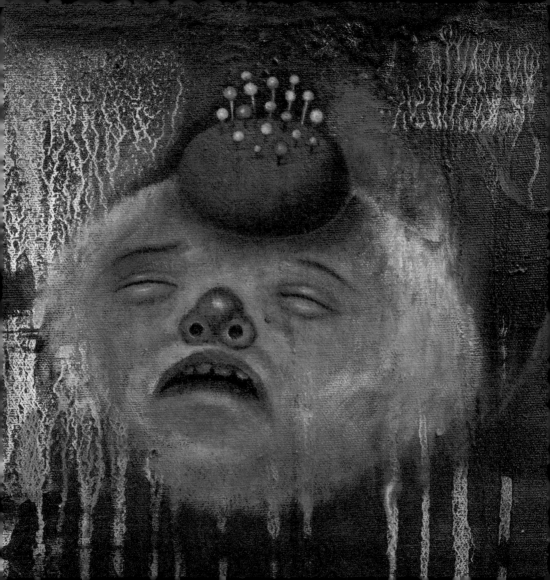

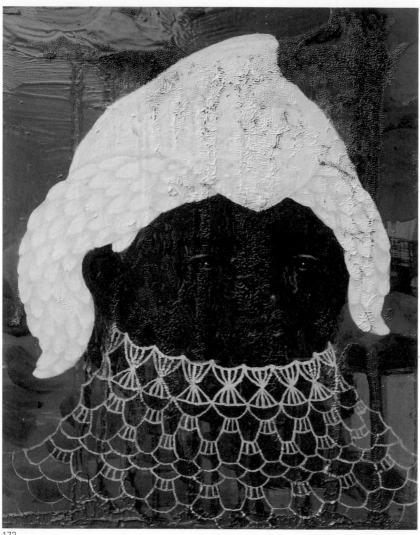

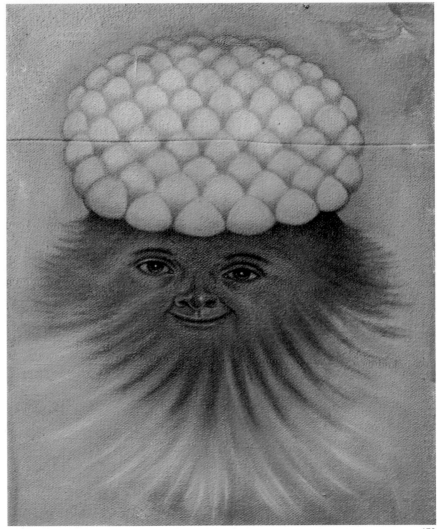

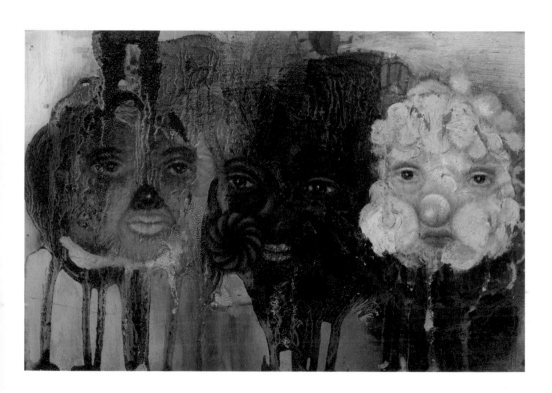

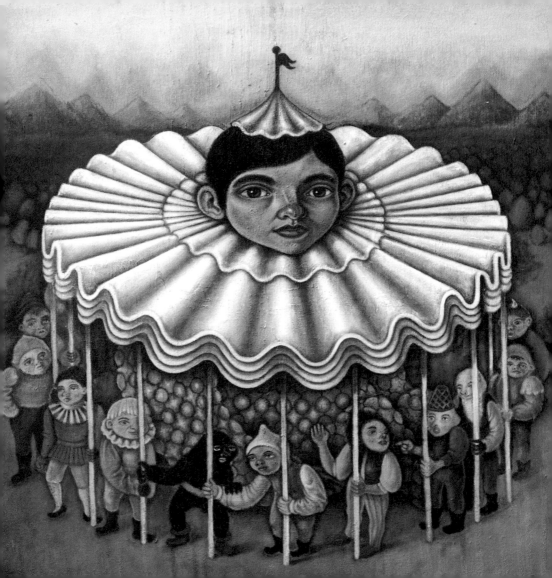

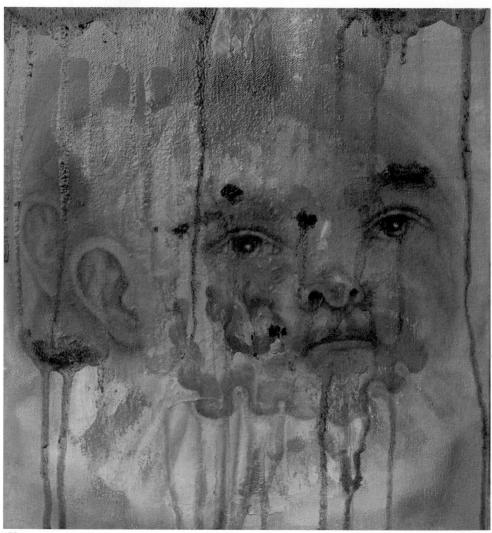

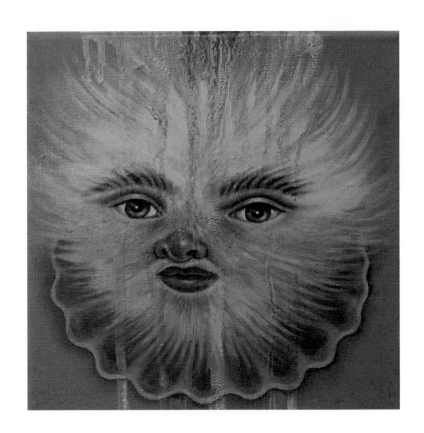

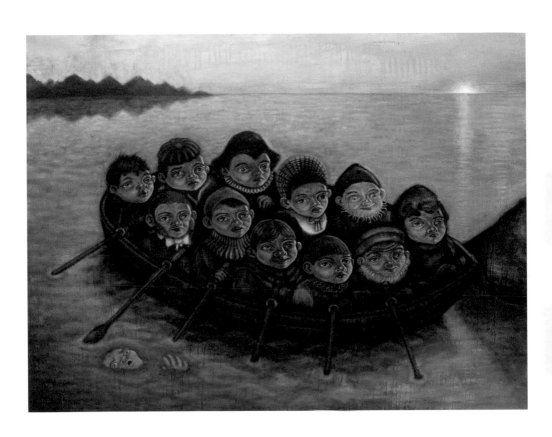

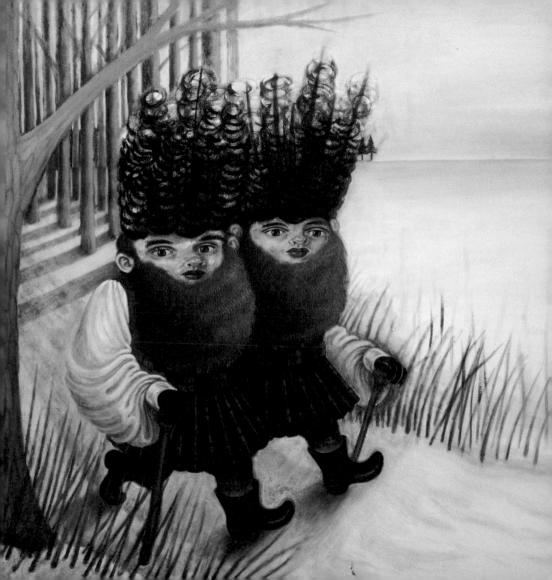

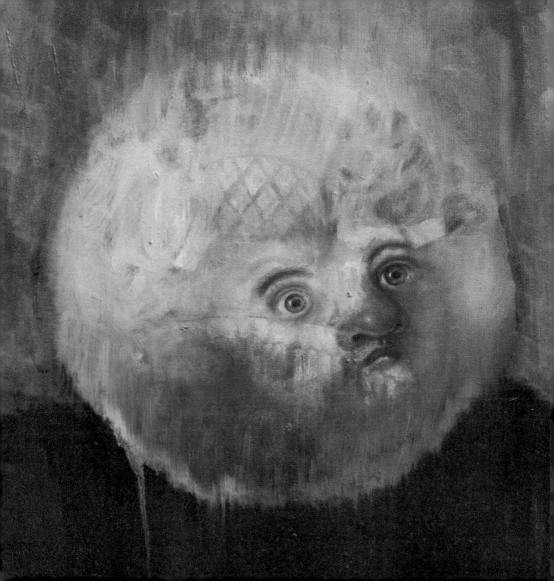

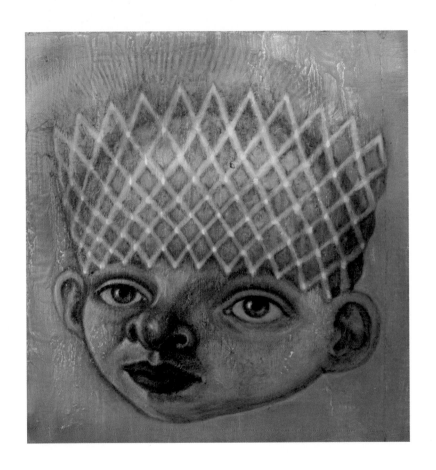

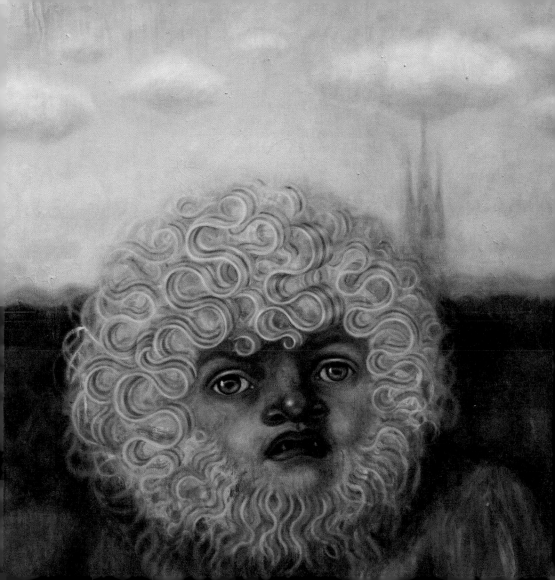

ACKNOWLEDGMENTS

First and foremost, I would like to thank Andy Brown for taking an interest in my work and for putting this book together. Thank you for being so patient, encouraging and helpful during the entire process and for making the experience so special.

Also, to Tom Sardelic for putting in so many hours of work colouring, lettering and photo retouching and for being so supportive and devoted.

Special thanks to my parents, Mark and Marie, and my big brother Sean, and his wife Jen, for always encouraging me in my artistic endeavours.

And to Amy Bowles for being such an inspiration to me and for being such a dear friend.

Thanks to Katharine Mulherin for the years of exhibiting my work and for her ongoing support and guidance.

And to Shary Boyle for all the engaging talks over coffee and, of course, for introducing me to Andy Brown.

Special thanks to Sylvie Dareche, Jo Abrams, Lee Henderson, Danny Michel, Drue Langlois, Michael Fuller, Catherine Stockhausen, and Rafael Gomez for all their help and contributions to this book.

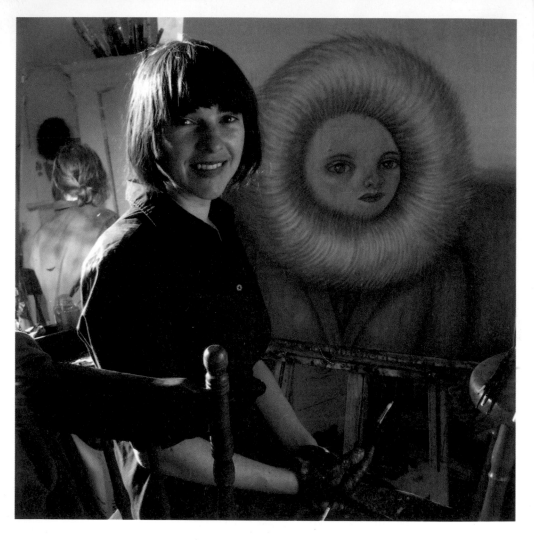